SAY YES

A JOURNAL FOR DREAMING BIG

by Leah Reena Goren

CHRONICLE BOOKS
SAN FRANCISCO

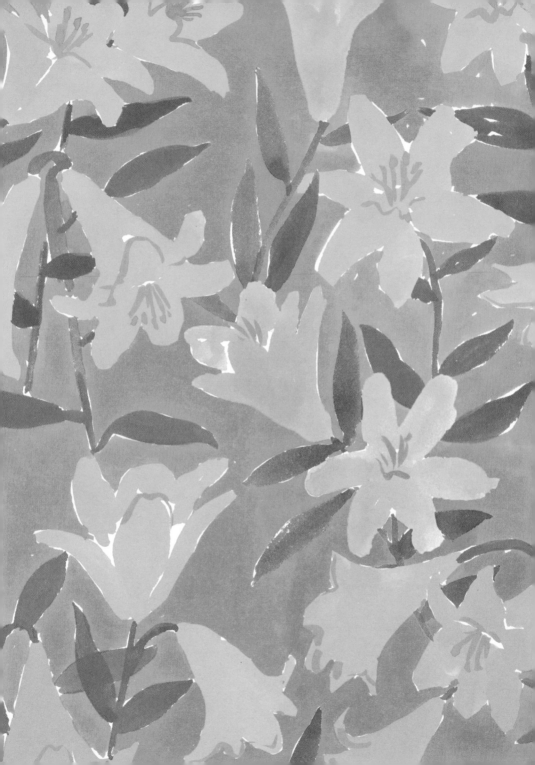

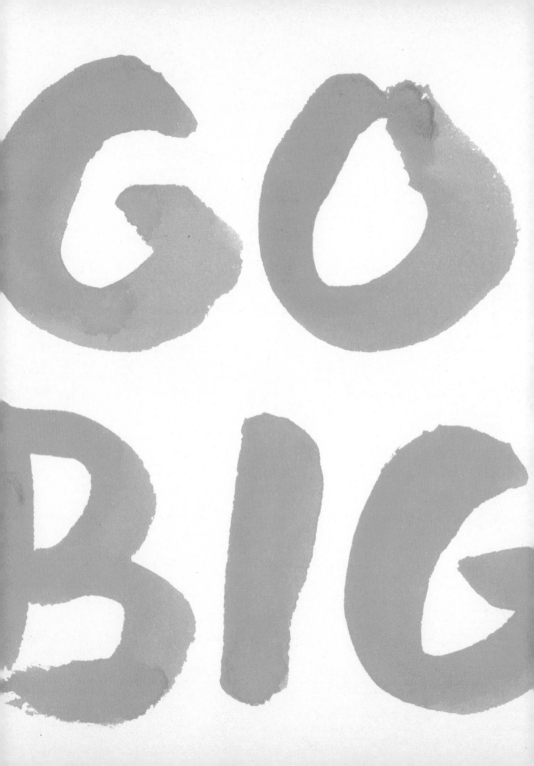

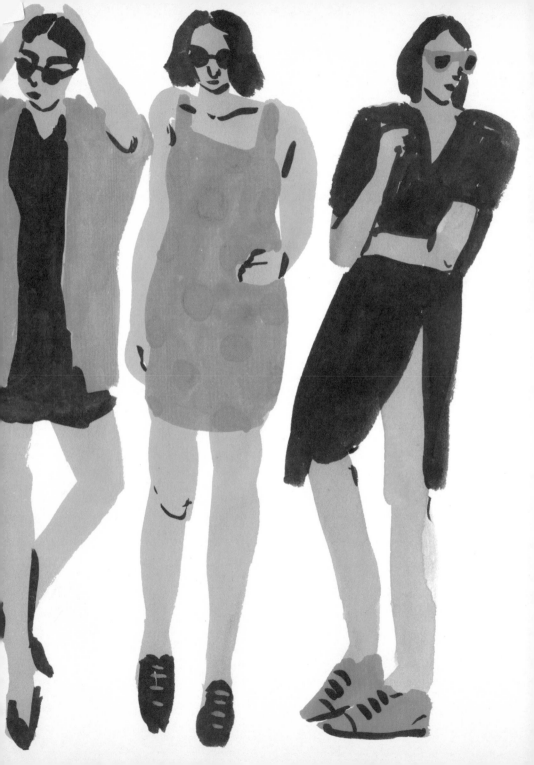

loose

What do you love?

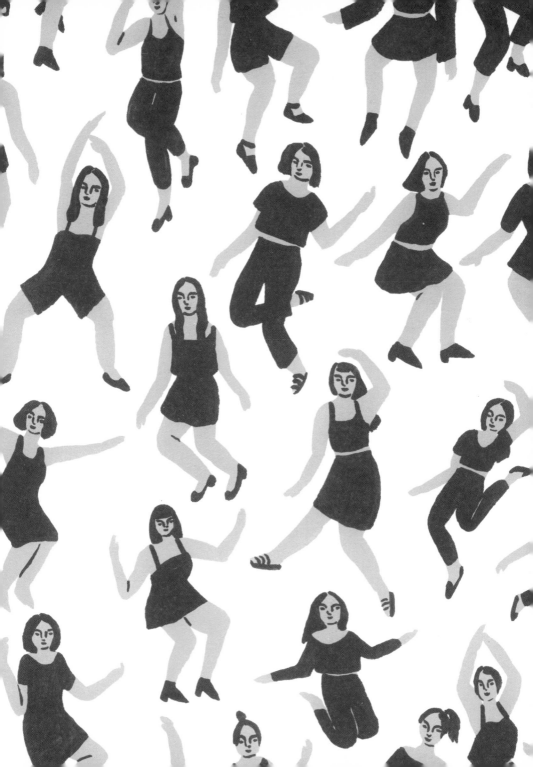

Do the

work

LOOK AROUND YOU

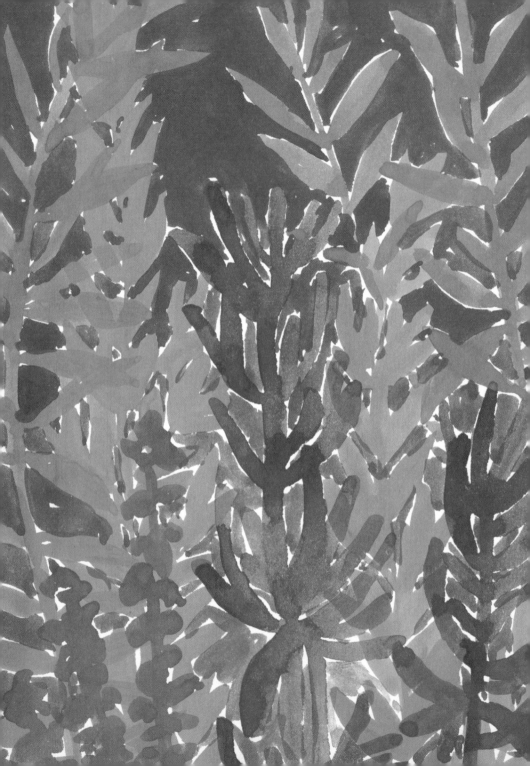

The
WORLD
Awaits

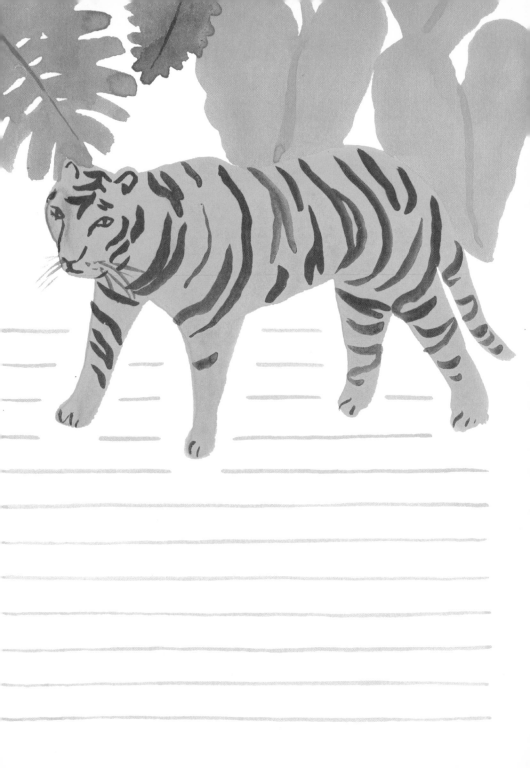

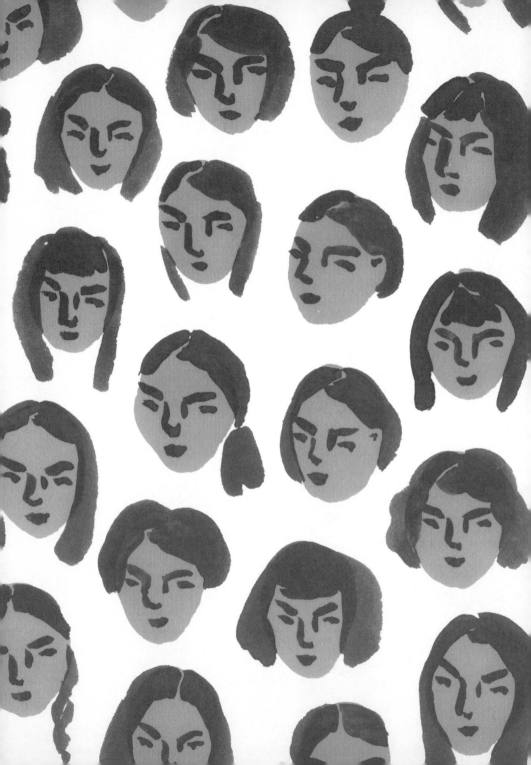

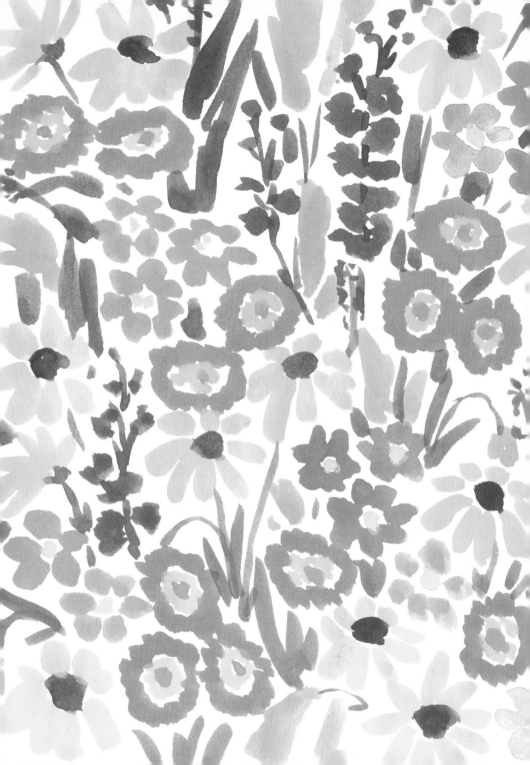

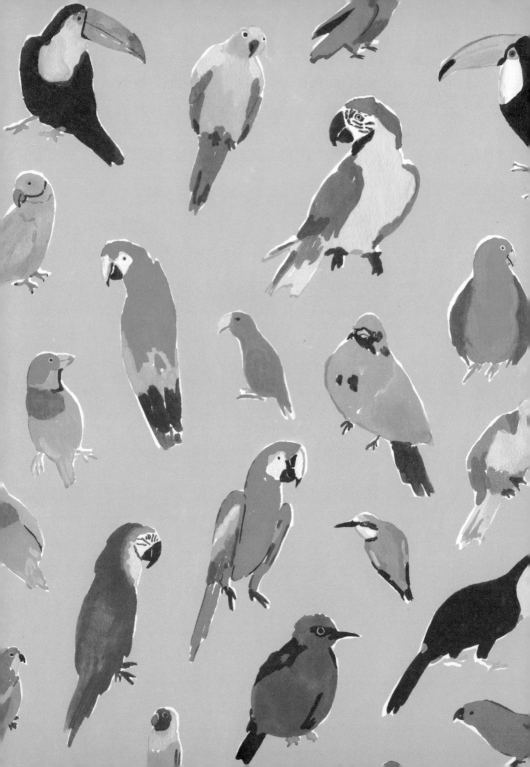

PLAY WITH COLOR

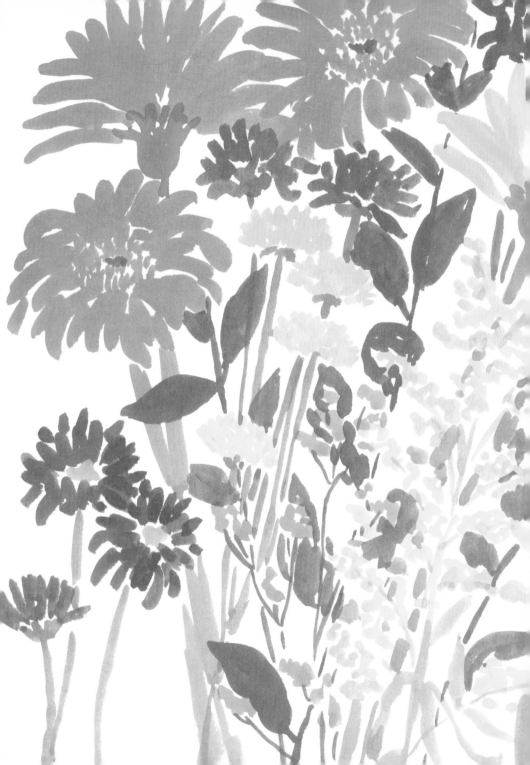

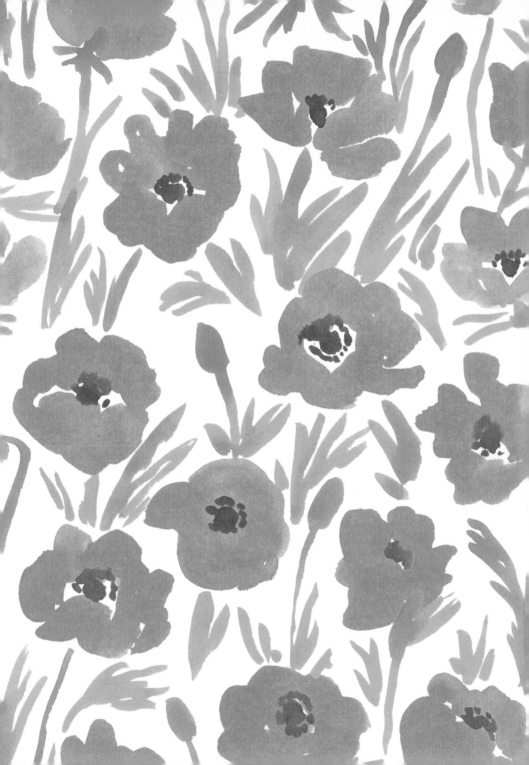

Style and

Substance

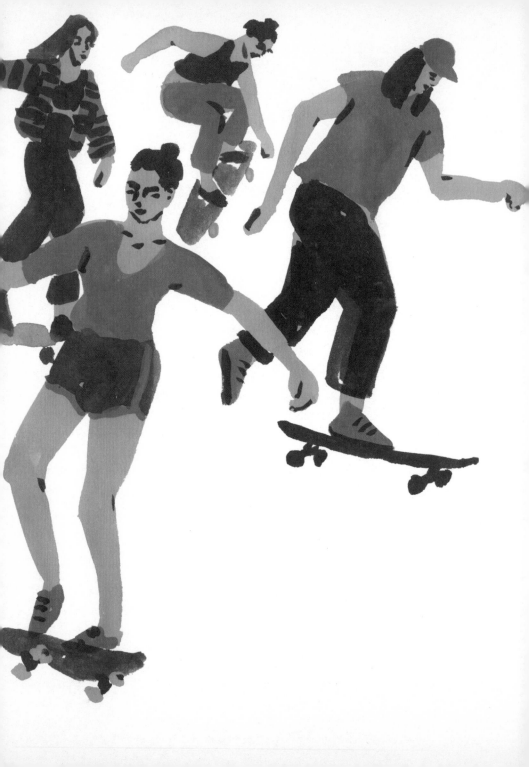

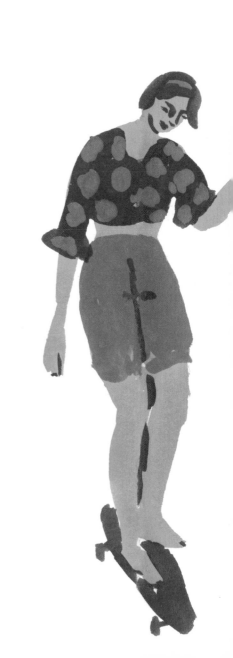

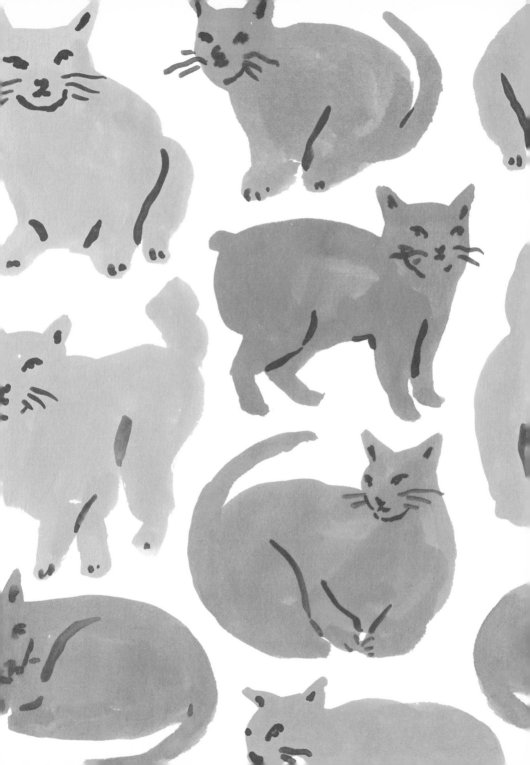

Laugh til

it hurts

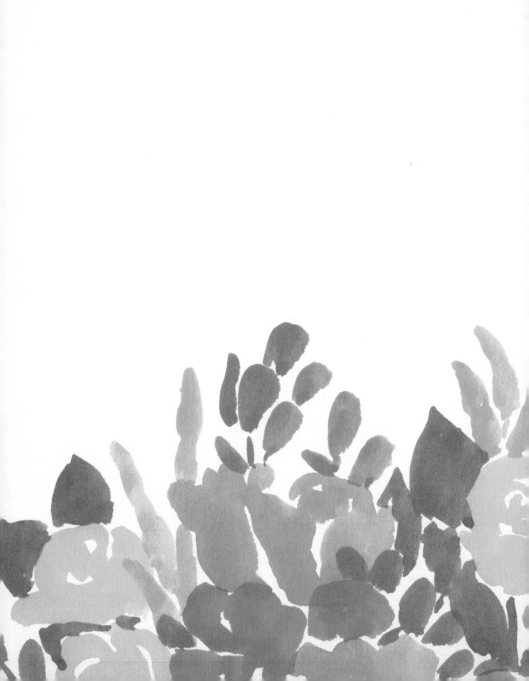

write

your

story

DIVE

YOU ARE

FANTA

ASTIC

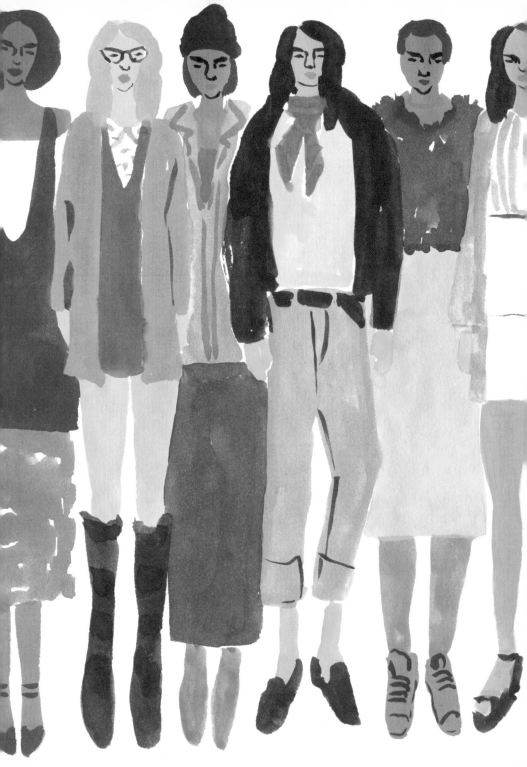

Find your people

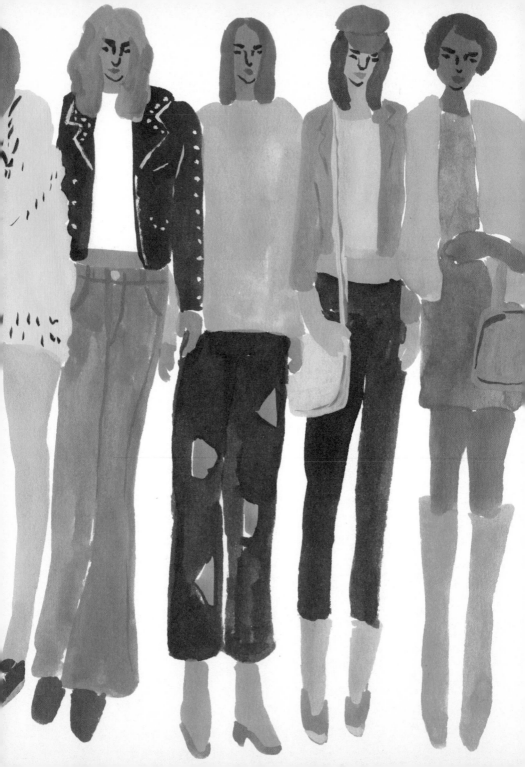

Warmth and Sunlight

raindrops and

starlight

TAKE YOUR TIME

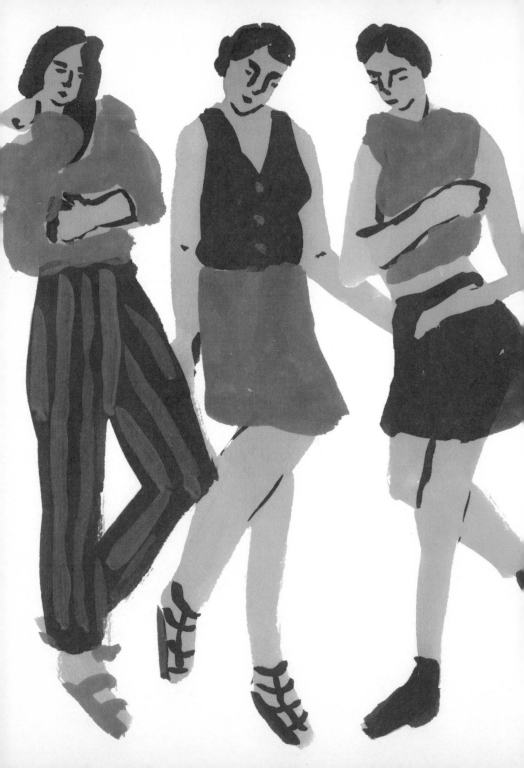

SAY

YES

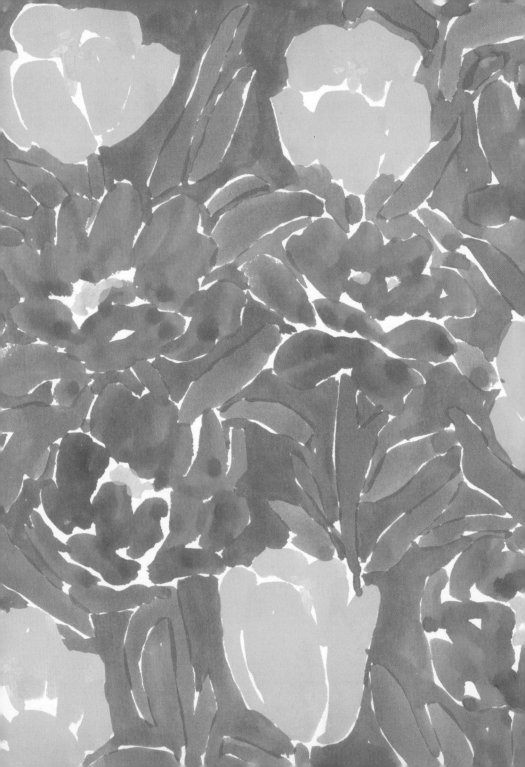

eam—

ISBN 978-1-4521-6441-0

Manufactured in China
Design by Kayla Ferriera

10 9 8 7 6 5 4 3 2 1

Chronicle Books publishes distinctive books and gifts. From
award-winning children's titles, bestselling cookbooks, and eclectic
pop culture to acclaimed works of art and design, stationery, and
journals, we craft publishing that's instantly recognizable for its
spirit and creativity. Enjoy our publishing and become part of our
community at www.chroniclebooks.com.

Special quantity discounts are available to corporations
and other organizations. Contact our premiums department at
corporatesales@chroniclebooks.com or at 1-800-759-0190.

Chronicle Books LLC
680 Second Street
San Francisco, California 94107
www.chroniclebooks.com